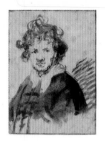

Rembrandt

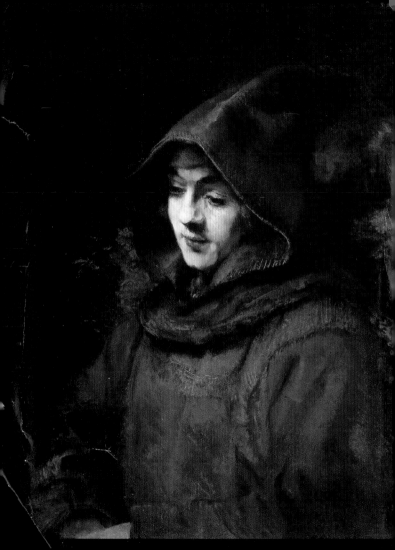

LIVES OF

REMBRANDT

BY

JOACHIM VON SANDRART,
FILIPPO BALDINUCCI,
AND
ARNOLD HOUBRAKEN

with an introduction by
CHARLES FORD

PALLAS ATHENE

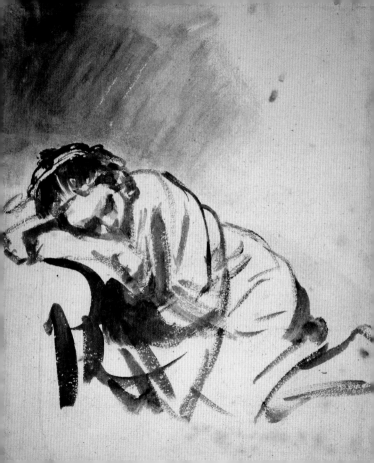

CONTENTS

Opposite: Young woman sleeping (?Hendrickje Stoffels), c. 1655

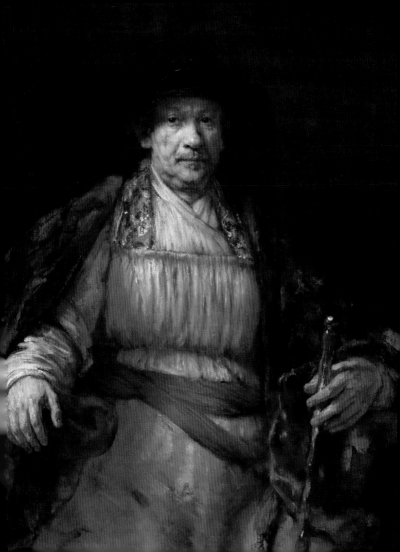

INTRODUCTION

CHARLES FORD

Rembrandt was quite possibly the most talked-about artist of his time – and just possibly of any time. These three biographies, published between five and fifty years after his death, and based in part on personal recollections, vividly attest the fascination of his art for contemporaries. But it may surprise us to find that this was a horrified fascination. If Rembrandt is today for many people a touchstone of artistic endeavour, for these early critics it turns out to be a touchstone of what art should not be.

Sandrart, Baldinucci and Houbraken, German, Italian and Dutch respectively, represent a broad swathe of opinion. Joachim von Sandrart (1606-1688) was a much travelled Nuremberg painter. He visited the Netherlands in the 1640s where he met Rembrandt, then at the height of his fame. Sandrart painted a group portrait which hung beside Rembrandt's Night Watch *in the Kloveniersdoelen Militia Hall – the paintings still hang together in Amsterdam's Rijksmuseum. Although celebrated as a painter during his lifetime he is now best known*

Opposite: Self-Portrait, 1658

as the author of the Teutsche Akademie *('The German Academy', 1675-1679). This is a lengthy and compendious work covering art and architectural theory as well as artistic biography. His literary ambition is evidenced by the appearance of a Latin edition of this work in 1683. Filippo Baldinucci (1624-1697) was also an artist, but he is also now best known as a writer. Born in Florence, he worked for the Medici family cataloguing their collections of drawings and paintings, and he remains an important figure in the history of connoisseurship. He wrote a biographical dictionary of artists, as well as shorter works such as the* Cominciamento e Progresso dell'arte d'intagliare… *('Origins and development of the art of engraving…', 1686) in which we find his account of Rembrandt. He had no direct knowledge of Rembrandt except, as he records, through knowing a former pupil living in Rome. Arnold Houbraken (1660-1719) was born in Dordrecht and worked as a painter and printmaker; he too is now best known as a writer.* De groote Schouburgh der Nederlantsche Konstschilders en Schilderessen *('The great Theatre of Dutch Painters and Painteresses', 1718–21) is an important source on Dutch painters of the 17th century, with much of the information obtained from living relatives and pupils of the old masters. Houbraken had been trained by Samuel van Hoogstraten, who had been a pupil of Rembrandt.*

When we read the biographies it becomes immediately apparent that all three writers disapproved of Rembrandt, which begs the question: why did they chose to write about him? The reason is that, for critics of their generation, grounded in the newly invigorated classicism of the second-half of the seventeenth century, Rembrandt (for all the appeal of his works, and perhaps because of the appeal of his works) represented a threat. These critics tell us about Rembrandt to warn us about Rembrandt.

'Classicism' was gaining ground during the period – especially in the newly founded Academies, where it was becoming increasingly formalised as a system. Giovanni Pietro Bellori, friend and ally of Poussin and the voice of the French Academy in Rome, was a key figure. He wrote an important history of Renaissance art, the Vite de' pittori, scultori et architetti moderni *('The Lives of Modern Painters, Sculptors and Architects', 1672). In it he described how the whole Renaissance had entered a crisis during the later sixteenth century, which he explained as the simultaneous emergence of 'mannerism' and 'naturalism'. Mannerism Bellori defined as an art about art, divorced from the study of nature; naturalism was the over-zealous attention to nature, what he described as mere slavish imitation. Bellori argued that artists should synthesise art and nature. This synthesis should occur during the practice of drawing (in Italian: 'disegno'). During*

9

the preparation of their works artists must select from and then adapt nature according to an Idea. The capacity to use the Idea came in part from talent, and in part it was acquired. In order to be able to recognise the Idea, young artists should be taught the canon of great works of art; they should draw after good examples. As is the way with classicisms, this was not proposed as an innovation, but as a return to first principles, to the practice of Raphael and, before him, to that of antiquity.

Rembrandt's paintings fell short of this academic vision of art. Houbraken readily admitted that Rembrandt had a genius for drawing and painting from life, but lamented that his talent was intuitive and hardly an instructive example for young artists. For the classical critic Rembrandt's pictures did not represent the Idea. They judged his nudes and saw that he did not make judicious selections from nature; that is, his selection was not guided by a knowledge of classical art. Neither his paintings nor his prints made conventional, definitional use of line. His drawings did not represent the painstaking processes of composition. Although he sometimes used sketches, he never used preparatory cartoons and seems to have composed his pictures in paint on the canvas or panel. Baldinucci also lamented Rembrandt's ignorance of perspective.

Opposite: Sarah awaiting Tobit (?Hendrickje Stoffels), c. 1649

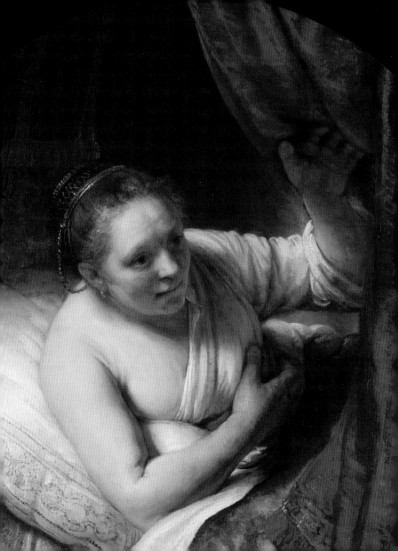

All these features of a properly classical painting constituted the science of art. Rembrandt's ability to prepare and handle paint merely evidenced his command of the craft of painting. Rembrandt was therefore perceived to be failing to rise to the proper level of professional competence required for a modern artist.

Sandrart, Baldinucci and Houbraken did not agree exactly on why Rembrandt failed, but their different explanations overlap. For example, they all agreed that Rembrandt claimed 'Nature' as his model rather than relying on the rules of art. In Bellori's history of art Caravaggio was a notorious and exemplary naturalist, and his biography of Caravaggio opens with a reference to the classical author Pliny, who had described a Greek sculptor called Demetrios in much the same terms. In a similar vein Houbraken interrupts his account of Rembrandt to quote Van Mander's account of Caravaggio. For these writers biography was a vehicle for philosophical reflection rather than a documented account of the life of an individual; we 'get the picture' by recognising prototypes. Because it was obvious to classical critics that Rembrandt did not work within the rules and procedures of art, it followed that he must be linked with Caravaggio the arch-naturalist. Caravaggio had been demonised by Bellori as an enemy of art and Caravaggio's supposed denial of the rules of art was explained as the

consequence of Lucifer-like pride. A whiff of sulphur accompanies similar references to Rembrandt's arrogant preference for his own experience of nature over the claims of the rules of art in all three biographies.

For renaissance critics the relationship between an artist and his works was summed up in the proverb 'every painter paints himself'. To understand the art object was to understand of the character of the artist (and vice versa). This is why biography plays such an important role in histories of art of the period. For Sandrart, Rembrandt was a badly educated plebeian and knew no better. Baldinucci said much the same, but he described a more complex web of factors, for example Rembrandt's bizarre religious beliefs. Baldinucci also associated Rembrandt's bad art with his (supposedly) ugly, plebeian body. For Baldinucci, Rembrandt was the vulgar, extravagant bene-ficiary of the ignorance of his patrons; that Rembrandt succeeded in the money-city of Amsterdam explains why he was so over-esteemed (here we can read an antipathy for the mercantile, Protestant north). Houbraken was gentler with Rembrandt, but could not, in the context of his general thesis, tolerate him. For Houbraken, Rembrandt's rejection of external authority, his love of

Overleaf: Portrait of a man with a tall hat and gloves; portrait of a woman with an ostrich-feather fan, 1658-1660

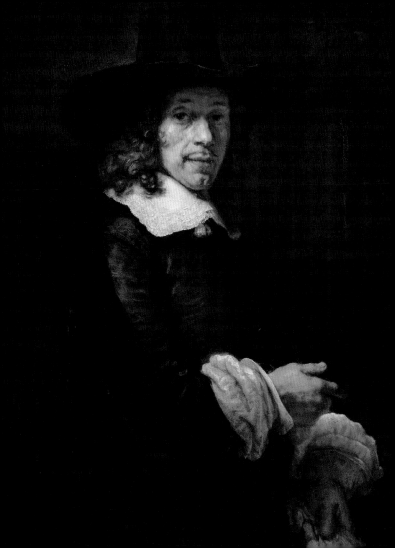

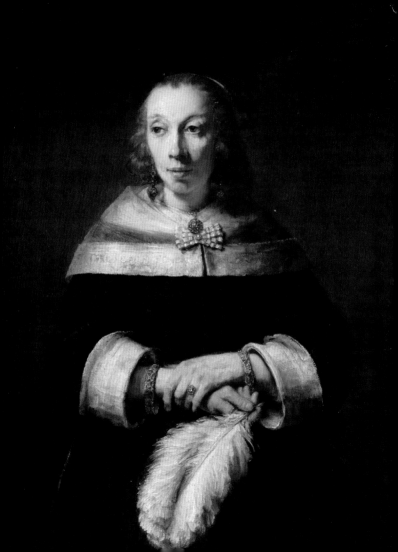

money, even his homeliness, all indicate classicism's 'other': the self-made, self-validating, craft-based painter for profit. It is Houbraken who tells the story of Rembrandt's dead monkey, commemorated in a painting against the sitter's wishes. We should read this as an allegory. The painting may well have existed, but need not have. In the renaissance, the monkey was a ubiquitous emblem of slavish imitation and in the context of the biography the symbolism is compelling. This symbolism takes on a special resonance when we are told that the painting of the monkey was eventually used as a partition between two student workrooms. Through these oblique references to prototypes, types and motifs the reader is edged towards a particular understanding of Rembrandt.

It would be a mistake, therefore, to read these texts as straightforward accounts of the historical Rembrandt. He is 'constructed' as the anti-classical painter; that is his role in the histories being told. We might contrast this figure to Rembrandt's own 'self-image' in the self-portraits. Here we are presented with a number of types, one of the most familiar being the majestic figure in historical robes wearing a gold chain, the very type of the renaissance courtier, derived from aristocratic portraiture. This would seem at

Opposite: Self-portrait with beret and two gold chains, 1642-43

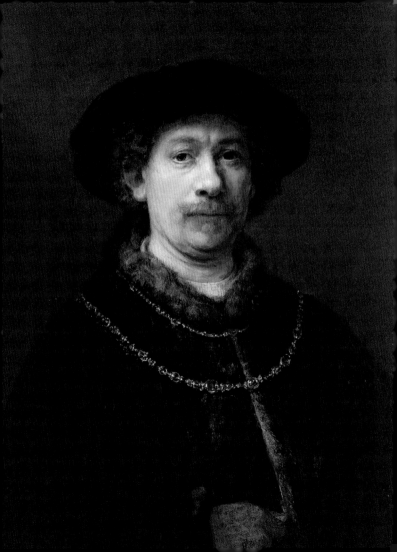

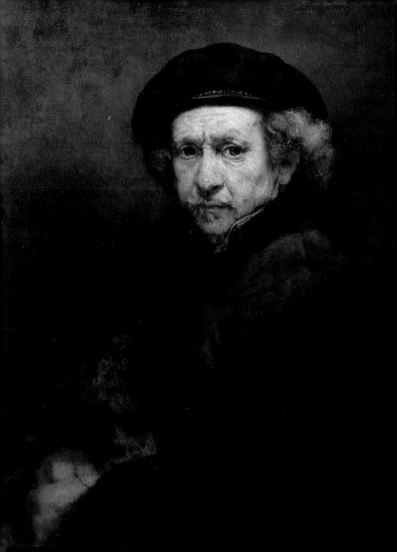

least to challenge the idea that Rembrandt was quite as vulgar or ignorant of the history of art as was claimed by his classical critics. The golden age of author-centred criticism came in the nineteenth and early twentieth centuries. In the generations following Romanticism these 'classicist' biographies were read with the value judgements inverted. The were reinterpreted as evidence of Rembrandt's honesty, of his bohemian free spirit. But those readings were still no more than caricatures, albeit approving ones. A popular image emerged of Rembrandt as an earthy, natural genius misunderstood by his contemporaries; this is what we are shown in Charles Laughton's portrayal of Rembrandt in Alexander Korda's film. In the last twenty five years art historians have retreated from such positions, and a modern student will be confronted with competing notions of 'historical agency' at work within 'discourses', 'culture', or simply 'contexts'.

* * *

Houbraken's account of Rembrandt's youth and training accords with our own best knowledge. Trained locally in Leiden, he went to Amsterdam where he studied briefly

Opposite: Self-portrait (based on Raphael's portrait of Baldassare Castiglione, author of The Courtier), 1659

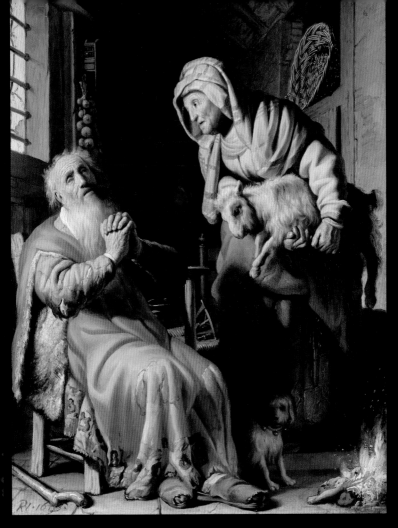

with Pieter Lastman, an artist who worked in what then would have stood out as a 'classical' manner. Lastman produced small-scale narrative pictures, full of accurate archaeological detail, in juicy, brightly-coloured paint. Lastman was expert in capturing the drama and emotional intensity of the situations he depicted and his compositional formulae, figural types and subject matters made a enormous impression on the young painter who frequently reworked them. Rembrandt returned to Leiden where he shared a workshop with another young painter, Jan Lievens. He also took on his first pupil, Gerrit Dou. The work of Lievens, Dou and Rembrandt from the period 1627-30 has often been confused, and attribution and re-attribution is likely to go on. Indeed, as Rembrandt worked in close proximity to others all his life, there is always a problem attributing any individual work absolutely to him at any time during his career. As well as painting, both Rembrandt and Lievens experimented with etching at this time.

In about 1630 Rembrandt moved to Amsterdam, his arrival was marked by a major portrait commission – the Anatomy Lesson of Dr Nicolaes Tulp (Mauritshuis,

Opposite: Anna accused by Tobit of stealing the kid, 1626

Overleaf: The Anatomy Lesson of Dr Nicolaes Tulp, 1632

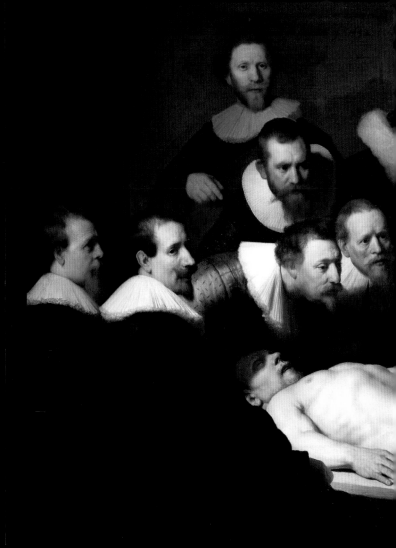

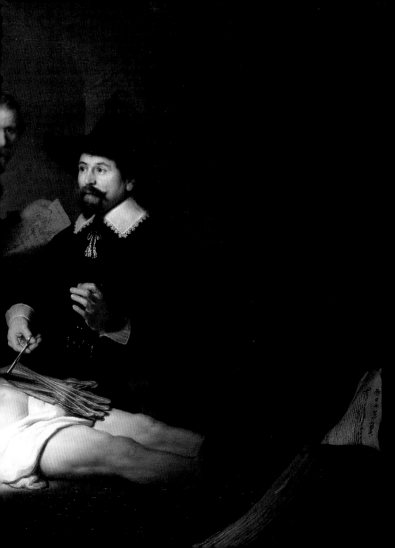

The Hague). Rembrandt's move was enabled by his business relationship with an important Amsterdam art dealer, Hendrick Uylenburgh, whose niece Saskia he would later marry. He was immediately successful in Amsterdam. He painted a series of portrait commissions remarkable for their combination of tight, highly finished detail and delightfully inventive compositional formulae. He also produced numerous subject pictures, some even for the court at The Hague, and initiated his famous studio full of students. Within a decade he was rich and famous – a fame amplified by the success of his prints which circulated throughout Europe.

Rembrandt's career might be thought of as having reached a high point in 1642 with the painting of The Company of Frans Banning Cock *('The Night Watch'; Rijksmuseum, Amsterdam, reproduced pp. 52-53). As Baldinucci reports,* The Night Watch *was well received (although Rembrandt wasn't paid quite as much for it as Baldinucci suggests, but then Baldinucci was playing on the legendary wealth of Amsterdam). But high point or not, it is clear that Rembrandt continued to obtain prestigious commissions and attract students long after 1642 (Bernhard Kiel, Baldinucci's source of information on*

Opposite: Samson threatening his father-in-law, 1635

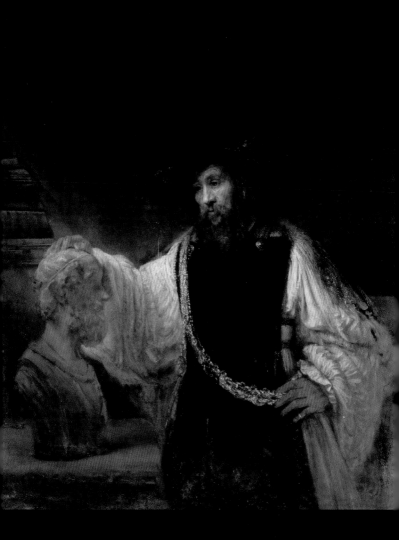

Rembrandt, studied and worked with him between 1648 and 1656). In 1656 Rembrandt began the process of bankruptcy. Even though his income declined he continued to live well, and what is more, he continued to live in his large house (now the Rembrandthuis) until after 1660. At about this time the celebrity of his prints drew him to the attention of a certain Don Ruffo, a Sicilian nobleman living in Messina, and Rembrandt was commissioned to paint the Aristotle Contemplating the Bust of Homer *(Metropolitan Museum, New York) and a 'portrait' of* Homer *(Metropolitan Museum, New York, ill. p. 100). Long after his bankruptcy he still painted works for public spaces – in 1662 he produced an important group portrait,* The Syndics of the Drapers' Guild *(Rijksmuseum, Amsterdam). Compared to most of his contemporaries Rembrandt had a long and successful career. In his prime he must have cut a figure in the salesrooms as he put together a remarkable collection of art and curiosities which we can admire from the inventory produced at his bankruptcy. He remained a friend of influential people throughout his life.*

In 1648, some years after Saskia's death in 1642,

Opposite: Aristotle contemplating the bust of Homer, 1653
Overleaf: The Syndics of the Drapers' Guild, 1662

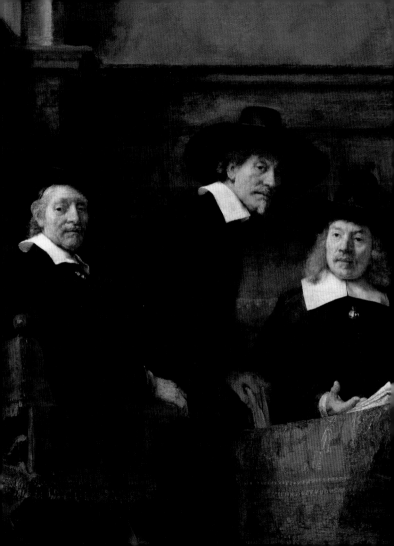

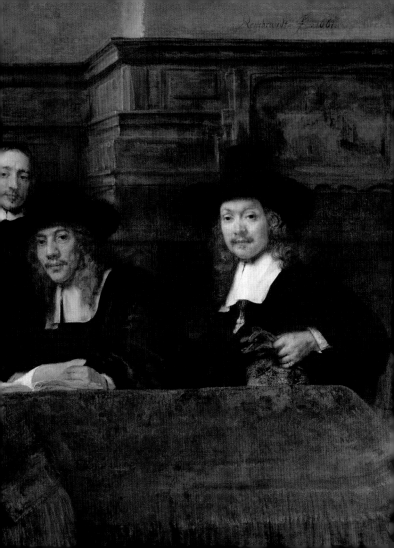

Hendrickje Stoffels moved in. She and Rembrandt did not marry, despite criticism from the elders of her church; it would seem that this was so that he could retain a legacy from Saskia's family. He held onto his earnings after his bankruptcy by dealing through Hendrickje and his son, Titus. Throughout his life he was notorious for delaying the delivery of works and we have a fair correspondence relating to that. We also have evidence that his workshop was enormously productive (there are far 'too many' Rembrandts) and we must conclude that, until the end of his career, demand for his paintings tended to outstrip supply. There are fewer paintings (and only two etchings) from the 1660s when, having moved house, he no longer ran his huge studio. And Rembrandt's success did not cease with his death. There is no reason to doubt Houbraken when he speaks of the enduring popularity of Rembrandt's works, and enough forgeries of his works in all media exist from all periods to suggest that he remained a favourite in the auction house.

Only Baldinucci wrote of Rembrandt's bankruptcy. News of this failed to reach Houbraken – or maybe the Dutch author chose to suppress it out of that sense of decorum he commends to the artist drawing from nature.

Opposite: Hendrickje Stoffels, c. 1654

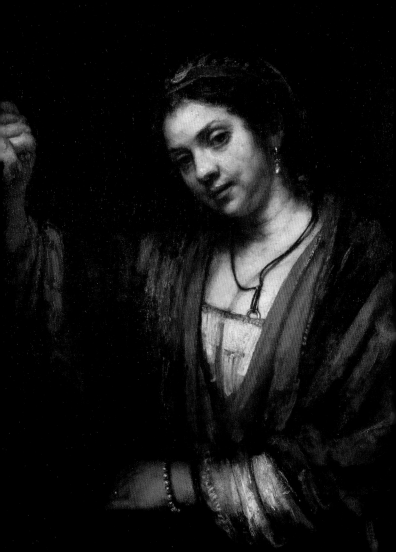

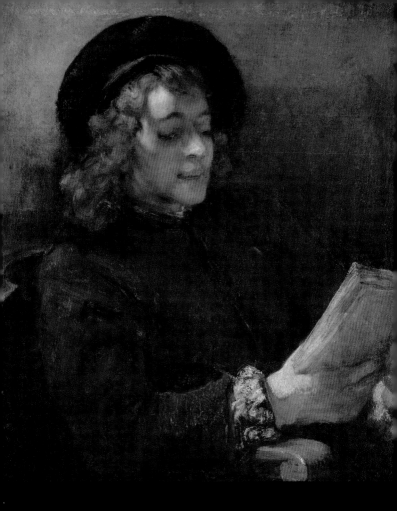

Rembrandt's financial dealings, as they have been revealed in recent documentary histories, are rather sordid. His bankruptcy was stretched out over several years and no doubt hurt others as much as him. When his son Titus married it was into another branch of the Uylenburgh family, effectively settling the outstanding problem of Saskia's legacy. Just how different that makes Rembrandt from any other middle-class Amsterdammer is hard to say. Hundreds of people went bankrupt every year in seventeenth-century Amsterdam. Documentary history relies upon court records, evidences of disputes, the transcripts of errors and disasters, and the most visible people in history tend to be the most litigious. Rembrandt is certainly visible in such histories. So we can conclude that Rembrandt was just that much more successful, and that much more accident-prone, than the average. What we do not need is the pious moralising offered by his three early biographers — no more than we need to sentimentalise him as a victim of an uncomprehending and uncaring world.

Rembrandt died in relative obscurity but he did not die alone, and his circumstances were much less miserable than average. True, Titus, his son, had died a few months earlier, but he had left a baby daughter, Titia. Cornelia,

Opposite: Titus reading, 1656

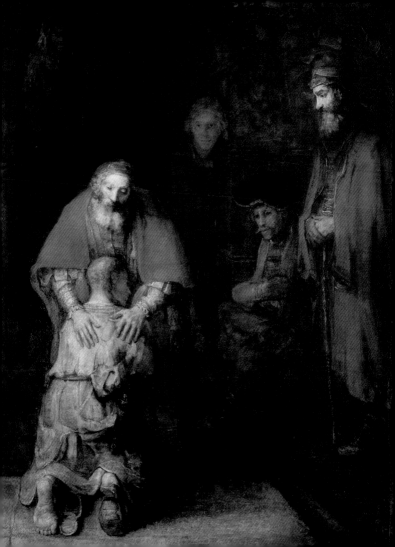

Rembrandt's daughter by Hendrickje Stoffels, was still in Amsterdam; she did not leave for Batavia, in the Dutch East Indies, with her new husband until the year after her father died. Like most seventeenth-century painters, many of them also very successful, Rembrandt was buried in an unmarked grave. His lasting memorial is a collection of paintings, drawings and prints and a widely dispersed paper trail of documents. The works and the documents have been put together in different ways over the years to produce markedly different pictures. At the moment a very purist scholarship has limited his paintings to a mere 350 or so; time was that he was author of over 1000 paintings.

We get the 'Rembrandt' we deserve. The following biographies show how this astonishing man, the most discussed painter of his generation, continued to function within a succeeding generation's debates about the very value of art. Indeed, it is clear that what was at stake were the values of civilisation itself. Remarkably, Rembrandt and his performance of the art of painting continues to feature in such debates right down to our own day. This is why these historical texts deserve sympathetic – and critical – reading and re-reading.

Opposite: The return of the Prodigal Son , 1669

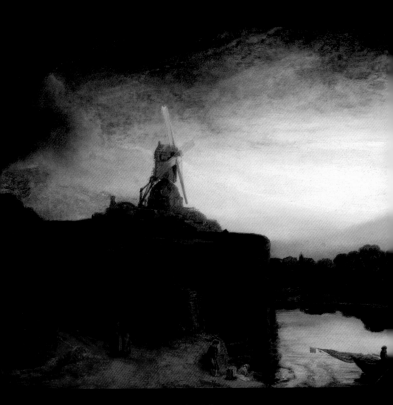

The Mill,
1645-8

JOACHIM VON SANDRART

Life of Rembrandt

from
Teutsche Academie
1675

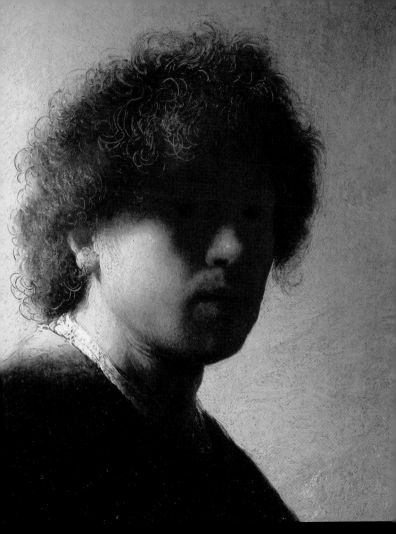

IT is almost to be wondered at that, being merely someone sprung up from the flatland and but the son of a miller, the excellent Rembrandt von Rijn [sic] was driven by nature towards noble art, and that it should happen in such a way that he achieved such a high eminence in it – which he gained through immense hard work, his innate predilection and natural talent. He started in Amsterdam under the celebrated Lastman, and, thanks to his inherent gifts, unsparing industry and continuous practice, he lacked for nothing – except that he had not visited Italy and other places where he might have studied the Antique and the theory of art. This was a defect all the more serious since he only read Netherlandish poorly, and therefore gained little from reading. Consequently he stuck with his own manner of painting, and did not hesitate to oppose and contradict our rules of art such as anatomy and the proportions of the human body, perspective and the usefulness of classical statues, Raphael's drawing and well-judged composition, and the academies which are so particularly necessary for our profession. In making this choice he argued that one should be guided by Nature alone, and by no other

Opposite: Self-portrait, c. 1628

*Portrait of the Mennonite
Preacher Cornelis Claesz.
Anslo and his wife Alltje
Gerritsdr. Shouten, 1641*

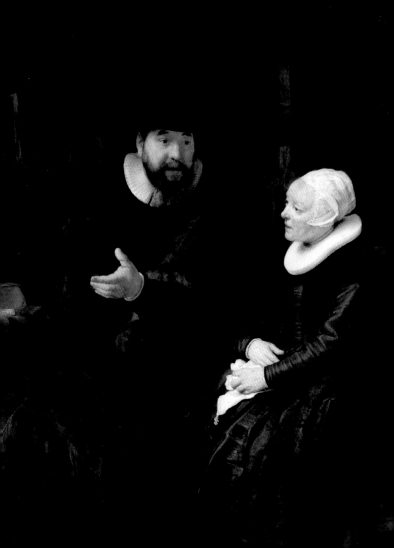

rules. As a result he approved it when highlights, shadows and outlines served the demands of painting, even if that neglected [proper spatial organisation], as long as [in his opinion] they seemed to work and to be suitable. Clean outlines ought really to be drawn in their proper place and in order to conceal the danger [of this lack] in his works, he filled his paintings with pitch-black; and so it was that he demanded nothing from his pictures as long as they maintained a universal harmony. As regards 'universal harmony', he excelled in achieving it, and knew not only how to depict the simplicity of nature accurately, but also how to embellish it with natural vigour in painting, and with powerful emphasis. This he achieved notably in half-length pictures and in heads of old people – nay, in little pieces, in elegant dresses and other pleasant knick-knacks.

He has also etched very many and various things on copper plates, published by him in print. It is obvious from all of this that he was a most hardworking and indefatigable man. As a result good fortune brought him riches and filled his house in Amsterdam with almost innumerable young people of good family, who came to him for instruction and tuition. Each paid him 100 florins a year. To this we must add the profit which he made out of the

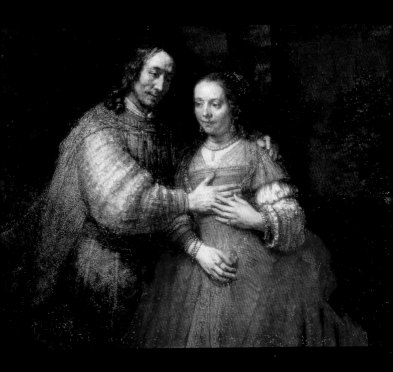

A man embracing a woman,
possibly Jephtah about to sacrifice his daughter,
('The Jewish Bride'), c. 1663

pictures and engravings of these pupils, amounting to some 2,000 to 2,500 florins each – as well as his earnings from his own handiwork. It is certain that if he had been able to please people and to look after his affairs properly, he would have increased his wealth considerably. For, although he was not a spendthrift, he did not know how to keep his station, and always associated with the lower orders, on account of which he was also hampered in his work.

It redounds to his praise that he knew how to mix and imitate colours most intelligently and artistically, and in conformity with their individual character, and how to apply them naturally, vividly and well on the picture. In so doing he has opened the eyes of all those who, through following the common practice, seem more like dyers than painters. They place the hardness and coarseness of the colours quite brazenly directly next to one another so that they have absolutely nothing in common with nature, but resemble the colour boxes you see in shops or the cloths brought from dyers. For the rest, he was also a great lover of art in its various forms, such as pictures, drawings, engravings and all sorts of foreign curiosities of which he possessed a great number, displaying great enthusiasm

Opposite: Girl at a window, 1645

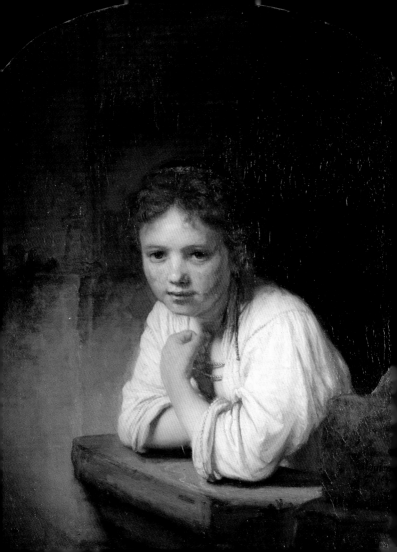

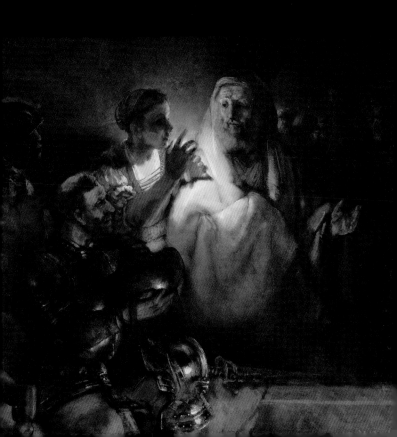

about such things. This was the reason why many people thought very highly of him and praised him.

In his works our artist introduced little light, except on the spot which he had chiefly in view; around this he balanced light and shade artistically. He also made thoughtful use of reflection by which light penetrates shade in a very well-judged manner; his colour glowed powerfully and he showed consummate judgement in everything to do with paint. He gave proof of great industry, patience and experience in his depiction of old people, their skin and their hair, so that he approached the representation of ordinary life very closely. He has, however, painted few subjects from classical poetry, allegories or striking historical scenes; he has mostly painted ordinary subjects, subjects without special significance, subjects that pleased him and were *schilderachtig* [painterly] as the people of the Low Countries say. Subjects which are, at the same time, full of charm and sought out in nature. He died in Amsterdam and is survived by a son who is said also to have good artistic judgement.

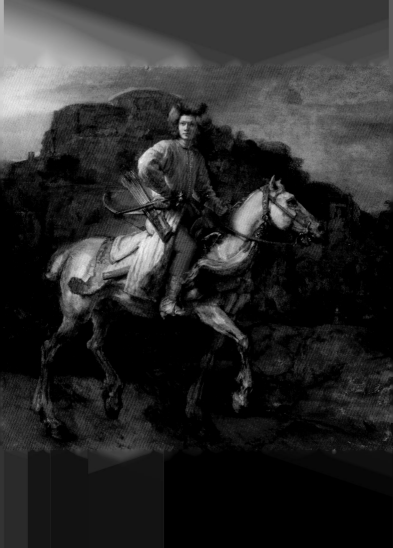

FILIPPO BALDINUCCI

Life of
Rembrandt

from the

*Cominciamento e Progresso
dell'arte d'intagliare in rame
colle vita de' piu eccellenti
maestri della stessa
professione*

1686

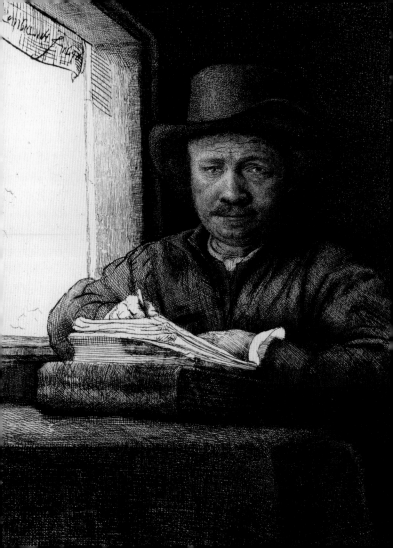

About the year 1640 there lived and worked in Amsterdam Reimbrond Vainrein [sic], who in our tongue we call Rembrante del Reno [sic], born in Leiden: a painter, in truth, much more highly esteemed than his worth. He painted a large canvas, which was housed in the residence of the foreign Cavaliers, in which he portrayed a detachment of one of the Citizen Companies which existed over there.* This brought him such fame as was scarcely ever achieved by any other painter in those parts. The reason for this, more than any other, was that among the figures he had represented one with his foot raised in the act of marching and holding in his hand a partisan so well drawn in perspective that, though upon the picture surface it is no more than half a yard, it yet appeared to every one to be seen at its full length. The rest of the picture, however, was jumbled and confused to such an degree that the other figures could scarcely be distinguished one from another, in spite of their being all closely studied from life. And this despite the fact that the painter was held in such high esteem. For this picture, which luckily for him his contemporaries greatly admired, he

* 'The Night Watch', reproduced overleaf

Opposite: Self-portrait drawing at a window, etching and drypoint, 1648

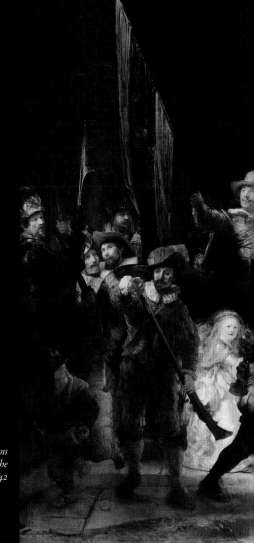

The company of Frans Banning Cocq ('The Night Watch'), 1642

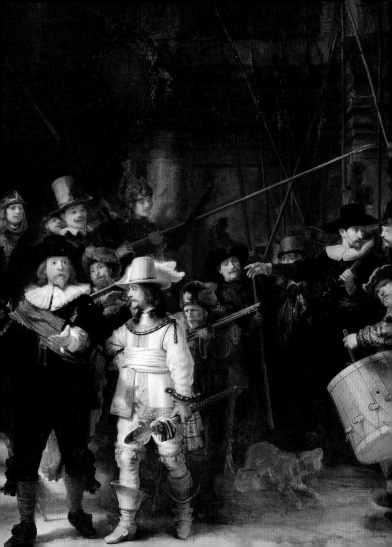

was paid 4,000 scudi in Dutch money, which corresponds to about 3,500 of our Tuscan currency. In the house of a merchant who was a magistrate of Amsterdam he painted in oils on the wall many pictures of stories of Ovid.[1] In Italy, judging solely from what has come to our knowledge, there are two pictures by him: one, in Rome, in the Gallery of Prince Pamfili, the head of a young man and wearing a turban;[2] the other in Florence, in the Royal Gallery, in the room of portraits of painters – his own portrait.[3] This artist professed in those days the religion of the Mennonites, which, though false too, is yet opposed to that of Calvin, inasmuch as they do not practise the rite of baptism before the age of thirty. They do not elect educated preachers, but employ for such posts men of humble condition, as long as they consider them to be what we would call honourable and just, and for the rest they live following their fancy.

This painter and engraver, who on account of his mental make-up did not have as much self-control as others, was also most extravagant in his style of painting. He evolved for himself a manner which may be called entirely his own. It was without contour or def-

[1] Lost [2] Lost [3] Uffizi, Florence

Opposite: Self-portrait as the Apostle Paul, 1661

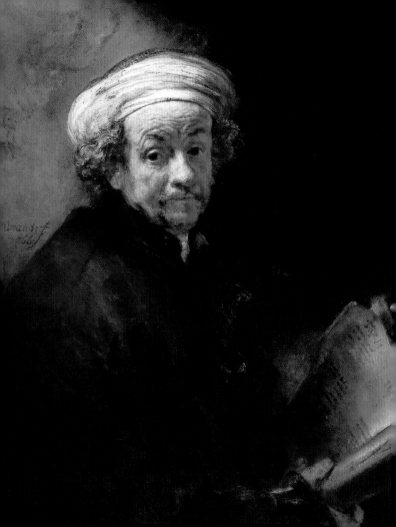

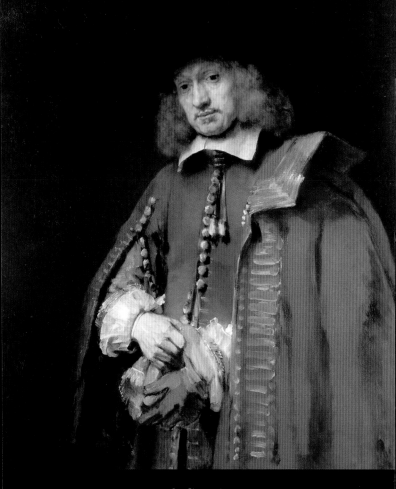

Jan Six, c. 1654

inition by means of inner and outer lines, but consisted entirely of violent and repeated strokes – with great strength of darks after his own fashion, but without any deep dark shades. And what is almost impossible to understand is this: how, painting by means of such strokes, he managed to work so slowly, and why it was that he competed his works with an unequalled tardiness and laboriousness. He could have painted a great many portraits, owing to the great prestige which in those parts had been gained by his colouring (to which, unfortunately, his draughtsmanship did not measure up). But when it became commonly known that whoever wanted to be portrayed by him had to sit to him for some two or three months, there were few who came forward. The cause of his slowness was that, immediately after the first coat had dried, he took up the picture again, repainting it with great and small strokes, so that at times the pigment in any one place was raised more than half the thickness of a finger. For this reason it may be said of him that he toiled restlessly, painted much and completed very few pictures. Nevertheless, he always managed to retain such prestige that a drawing by him, in which little or nothing could be seen, was sold by auction for 30 scudi. This is told by

[1] Untraced

Bernhardt Keil of Denmark, the much praised painter now working in Rome, who had been his apprentice for eight years. Rembrandt's extravagance of manner was entirely commensurate with his mode of living, since he was a most temperamental man and despised everyone. The ugly and plebeian face by which he was ill-favoured, was accompanied by untidy and dirty clothes, since it was his custom, when working, to wipe his brushes on himself, and to do other things of a similar nature. When he worked he would not have granted an audience to the first monarch in the world, who would have to have returned again and again until he had found him no longer busy. He often went to public sales by auction; and here he bought clothes that were old-fashioned and cast-off, as long as they struck him as bizarre and picturesque. Even though at times they were down-right dirty, he hung them on the walls of his studio among the beautiful curiosities which he also took pleasure in owning. These included every kind of old and modern arms – arrows, halberds, daggers, sabres, knives and so on – and innumerable quantities of exquisite drawings, engravings and medals, and every other thing which he thought a painter might ever need. He deserves great praise for a certain goodness of his, extravagant though it be, namely that, for the

sake of the great esteem in which he held his art, whenever things produced by great men of those parts were offered for sale, he bid so high at the outset that no one else came forward to bid. He said that he did this in order to emphasise the prestige of his profession. He was also very generous in lending those paraphernalia of his work to any other painter who might have needed them for some work of his.

The way in which this artist truly distinguished himself was in a certain most bizarre manner which he invented for etching on copper plates. This manner too was entirely his own, neither used again by others nor seen again: with certain scratches of varying strength and irregular and isolated strokes, a deep chiaroscuso of great strength nevertheless springing forth out of the whole. And it must be conceded that in this particular branch of engraving Rembrandt was much more highly esteemed by the professors of art than in his painting, in which it seems he had exceptional luck rather than any merit. Onto his engravings he usually inscribed, in badly formed, shapeless and tortuous letters, the word 'Rembrand'. Thanks to these engravings he achieved great riches, and proportionately with these there arose in him such pride and self-conceit that, since it seemed to him that his prints did not sell at the prices which he

felt they deserved, he imagined that he had found a method of increasing the desire of them universally. Hence at intolerable expense he had them bought back all over Europe, wherever he could find them, at any price. Among others he bought one for 50 scudi at a sale by auction in Amsterdam, a *Raising of Lazarus*, and this he did while himself possessing the copper-plate engraved by his own hand. Eventually, as a result of this wonderful idea, he spent all his substance to such an extent that he was reduced to extremities; and then something happened to him which is seldom told of other painters, namely that he went bankrupt. Thereafter he left Amsterdam and entered the service of the King of Sweden, where he died miserably about the year 1670. This is what we have been able to learn about this artist from someone who at the time knew him and saw a great deal of him. Whether he persisted in that false religion of his we have not been able to discover. Some of his pupils are still alive, for example Bernhardt Keil of Denmark, mentioned above, and Govaert Flinck of Amsterdam. In his colouring the latter much followed the manner of his master, but outlined figures much better. Lastly, among his pupils there was the painter Gerrit Dou of Leiden.

Opposite: Raising of Lazarus, c. 1632, etching

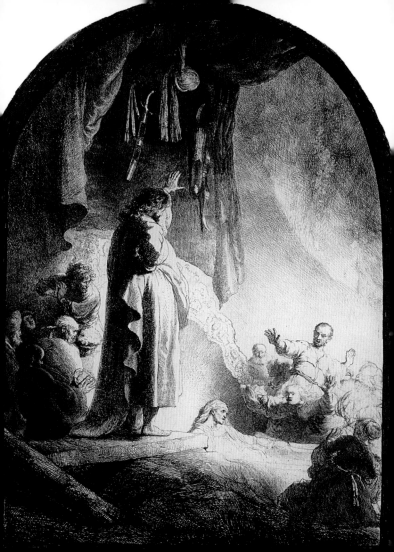

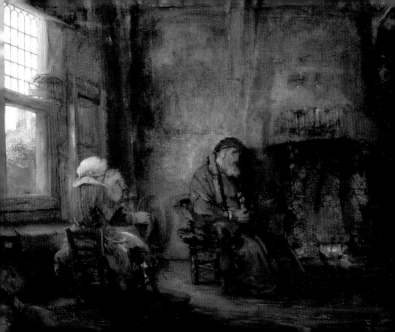

ARNOLD HOUBRAKEN

Life of Rembrandt

from

*De Groote Schouburgh
der Nederlandtsche
Konstschilders en
Schilderessen*

1718-21

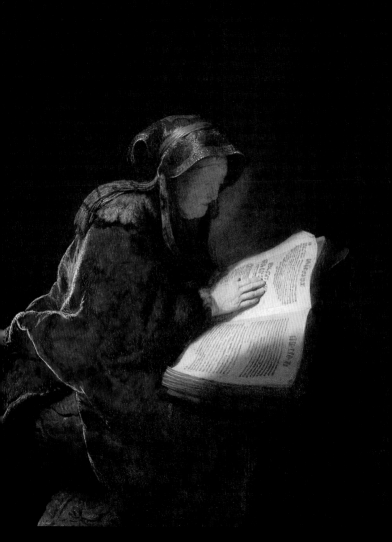

THIS year of 1606, so especially fruitful in producing excellent artists, also witnessed the birth of Rembrandt on the 15th of July, by the side of the the Rhine outside Leiden. His father, Harmen Gerritsz. van Rijn, made a very good living as a miller at the corn mill which lies on the Rhine between Leidendorp and Koukerk; his mother was Neeltgen Willemsdr. van Zuytbroeck.

As Rembrandt van Rijn was an only son his parents raised him to become an educated man.* They decided he should be taught Latin, to which end they sent him to school in Leiden. However, his particular inclination for drawing made them change their minds and they subsequently sent him to learn the principles of art with Jakob Isaackz. van Swanenburgh, with whom he remained three years. During this time he advanced so much that everyone there was astonished and all agreed that he would achieve great things. This persuaded his father to send him to Pieter Lastman in Amsterdam, in order that no

* In fact Rembrandt was the youngest but one of seven; his four brothers included a cobbler and a baker

Opposite: The Prophetess Hannah, sometimes known as Rembrandt's Mother, 1631

opportunity should be lacking as regards acquiring a solid foundation for the development of his art. He remained there six months, and after that spent a few months with Jacob Pynas. Then Rembrandt decided that thereafter he would practice art independently, and he succeeded wonderfully well from the start. Others believe that Pynas was his first teacher in art. Simon van Leewen says, in his short description of Leiden, that Joris van Schooten taught both Rembrandt and Jan Lievens.

Meanwhile, every day, diligently and with great enthusiasm, he practised art at his parents' house. Now and again he was visited by art lovers and they eventually recommended him to a lord in The Hague, as a consequence of which he took a certain piece[1] he had already made in order to show and offer it to him. Rembrandt carried it on foot to The Hague and sold it for a hundred guilders. He was immensely pleased, but being unused to having so much money in his purse he immediately wished to get home as quickly as possible so that his parents could share in his joy.

Going on foot was now beneath him, the journey by barge too common, thus he climbed onto the Leiden coach.

When they got to the inn at Den Deil and the

[1] Untraced

others got down from the coach for refreshment our Rembrandt remained sitting alone in the vehicle with his booty, not trusting to leave it. Then what happened? As soon as the the horses' feed had been removed, with the driver and the rest of the passengers preparing themselves to climb back up, the horses bolted and the coach abruptly set off. They galloped, turning neither to left nor right until, inside the Leiden gate, they halted the coach at the customary place in front of the inn. Everyone was astonished and asked how such a thing had happened. But Rembrandt didn't chose to discuss it. He climbed down from the coach and took himself and his purse to his parents, well satisfied that for nothing and free of charge he had been brought back to Leiden more speedily than the others.

Now he began to see, from this auspicious beginning, the prospect of earning money, and his passion was so spurred on towards art that he provided enough for all the art lovers. Thus he 'kept his hands busy', as the saying goes. When subsequently he turned to painting portraits as well as other pieces he was invited frequently to Amsterdam, and since that city seemed to him to be especially favourable, and his rise there to be propitious, he decided to settle there. This was in about the year 1630.

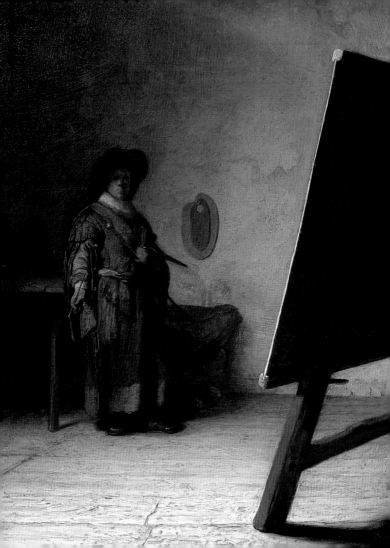

*Rembrandt in his
studio, c. 1626*

Work flowed in to him from all sides, as did numerous pupils. To which end he rented a warehouse on the Bloemgracht, where each of his pupils was assigned a small room (partitioned off with either paper or canvas) so that they could learn to paint from life without disturbing each other. But as is the way with young people, as soon as a large number are gathered together in one place, at some point something comical is bound to happen. One of them, needing a female model, brought her into his cubicle. This aroused the curiosity of the others so that, in their stocking feet (so as not to be heard) they took turns to enjoy the show by means of a small hole made deliberately for that purpose. Now all this took place on a warm summer's day, for which reason the draughtsman, or painter, had stripped himself naked just like the model. Exactly what discussions and considerations went on between these two the spectators of this comedy can attest. And it all took place at the very moment that Rembrandt arrived to see what his pupils were doing, passing among them to instruct them one after another as was his custom. Eventually he came to the room occupied by these naked lovers which he found locked shut. Advised about what was going on,

Opposite: Portrait of a young man seated with a hat, possibly Rembrandt's student Govaert Flinck, c. 1660

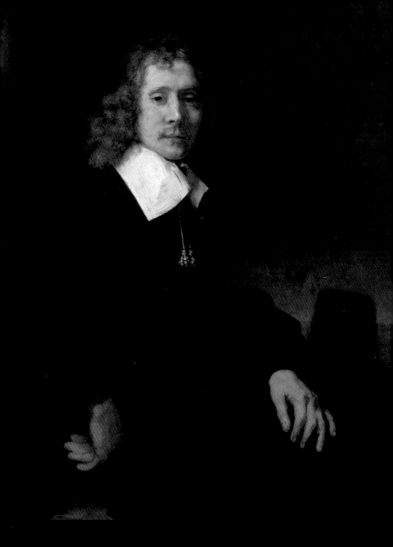

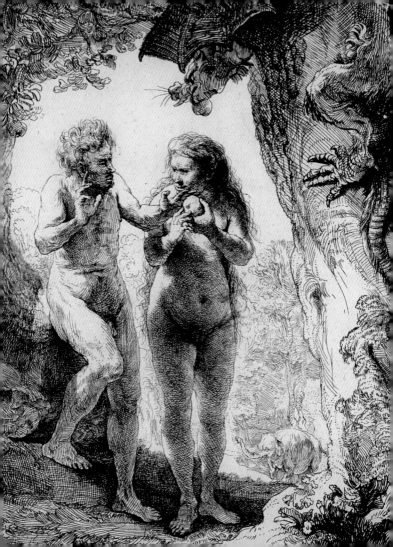

he peeped for a short while in silence at this spectacle through the hole until, among other things, he heard one of them say 'It is just as if we were Adam and Eve in Paradise, us both being naked.' At which, to their astonishment, he struck upon the door with his mahl-stick and cried out in a loud voice 'It is because you are naked that you must be expelled from Paradise!' He ordered his pupil under threat to open the door from the inside so that he could go in, upsetting the play of Adam and Eve and transforming a comedy into a tragedy. He drove out the pretended Adam and his Eve with blows, and in their panic they were still try-ing to dress themselves as they decended the stairs so that they should not arrive naked in the street.

As regards his art he was very inventive, which is why one frequently sees so many different sketches of the same subject by his hand, which are also full of alterations as regards characterisation, posture and details of costume. In this he deserves to be praised above others – especially those who combine in their works identical characterisations and draperies, as if the figures were all twins. Indeed, in that regard he excels all others. I know of no one else who has made so many alterations in the sketches for one and the

Opposite: Adam and Eve, etching and drypoint, 1638

same composition. This is a result of his thoughful consideration of the great number of emotions which necessarily come into play in the subjects he depicts, and which we see especially animating people's faces with firm and characteristic lines and which reveal themselves also in the distinctive posture of the body. To give an example: there are various sketches known to connoisseurs of drawing (in addition to two compositions published in print) representing the moment when Christ revealed himself to his disciples, who had gone with him to Emmaus, by breaking the bread. No fewer in number are the sketches of the faces of the two disciples as Christ disappears before their eyes, on account of which they are disturbed, confused and astonished. We have engraved one of them and reproduce it here for the instruction of young inexperienced painters; this is the one that we liked best on account of its depiction of the expression of emotion, the amazed disciples gaping at the empty chair where, moments before, Christ had been seated but from which he was now gone.*

Experts should not condemn my zeal – it is in order to make the point clear to the young, and they

* This is the only illustration of a work of art in the whole of Houbraken's book. Rembrandt's original is lost, though there is a copy by a close follower in the Fitzwilliam Museum, Cambridge.

will not repay my efforts ungratefully – for such exam-
ples are (as the Spanish say) 'like the hand which leads
the oxen to the water by its mouth'.

It is a pity, however, that he was so whimsical (or
whatever it was that drove him) in his readiness to
make so many alterations. Many works are only half
completed, paintings and even more so his etched
prints, those beginnings suggest to us the beauties we
would have had from his hand if he had brought
everything to fruition proportionate to the way he
began them. This is especially to be seen in the so-
called Hundred Guilder Print and others, the

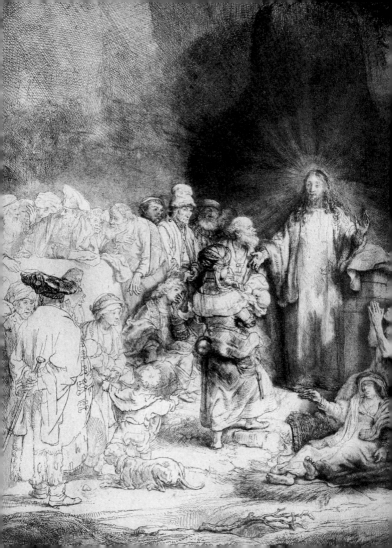

handling of which astonishes us as we cannot under-
stand how he was able to develop it from an prepara-
tory rough sketch. We can observe this process in the
little portrait of Lutma which one sees in the first state
as a rough sketch, then in a later state with a back-
ground and eventually as fully finished print. It is the
same with his paintings, some of which I have seen
with highly finished details, the rest of the composi-
tion slapped on carelessly as if with a coarse tarbrush.
And he would not be convinced that he ought do oth-
erwise, asserting that 'a painting is completed if the
Master has achieved what he set out to do'. This went
so far that he is said to have obscured a beautiful
Cleopatra in order to give full effect to a single pearl.[1]
An example of his pig-headedness regarding such
matters occurs to me. It once happened that his pet
monkey died suddenly when he was half-way through
painting a large portrait of a man, his wife and and
children. Having no other prepared canvas available
he painted the dead monkey into the picture.

[1] Untraced

*Previous pages: Christ healing the sick ('The Hundred Guilder Print'),
c. 1648, etching and drypoint*

*Opposite: Jan Lutma, counterproof of etching with
retouchings in Rembrandt's hand, 1656*

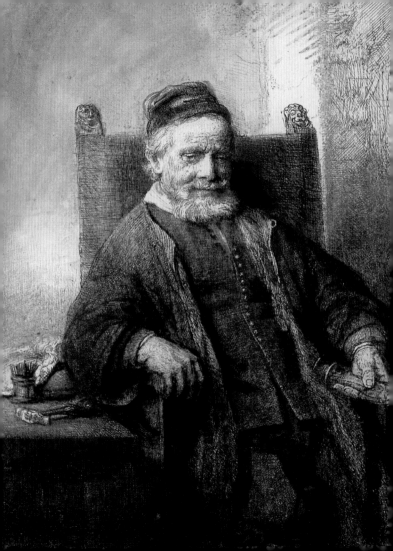

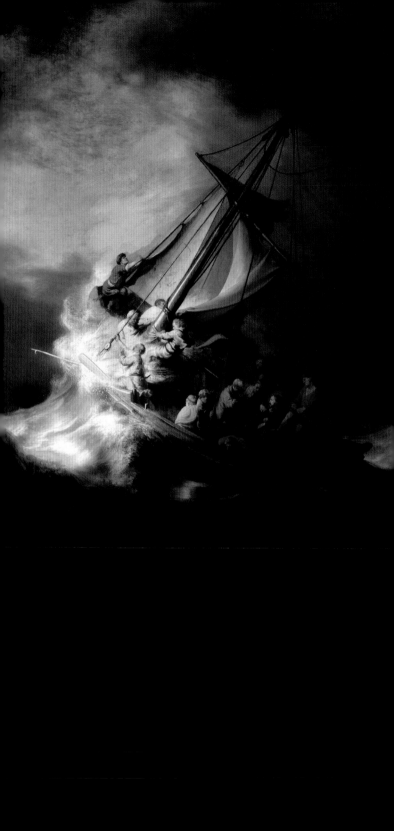

The people objected strongly to this, not willing that
their portraits should be arrayed alongside a disgusting
dead ape. But no, he was so enamoured of that study
of the dead monkey that he chose to leave the picture
unfinished and keep it as his own rather than please
them by painting it out; and that is what happened.[1]
The picture in question eventually served as a parti-
tion for his students. Nevertheless, many of his pieces
are still to be seen in the most famous cabinets of art
and they are, on the whole, completely painted and
finished – even though, several years ago, many were
purchased at high prices and carried off to Italy
and France.

I have remarked that in his early career he took
greater pains to complete his paintings than he did
later. Among various examples this is especially to be
seen in the piece called *St Peter's Boat*, which has hung
for many years in the cabinet of Mr Jan Jakobsz. van
Hinloopen, formerly Bailiff and Burgomaster of
Amsterdam.[2] The attitudes of the figures and the
expressions on their faces are depicted as naturally in
accordance with their situation as could be imagined,

[1] Untraced [2] Boston, Isabella Stewart Gardner Museum; miss-
ing since stolen in 1990 [3] Moscow, Pushkin Museum

Opposite: St Peter's Boat (Storm on the Sea of Galilee), 1633

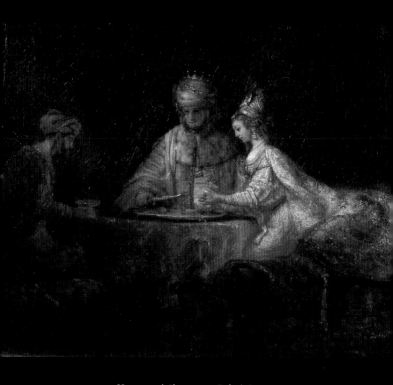

Haman and Ahasuerus at Esther's Feast, 1660

and furthermore it is painted with much more finish than one is accustomed to seeing in his work. Also, in the same collection, there is a painting by Rembrandt depicting Haman, Esther and Ahasuerus.[3] The poet Jan Vos, an astute judge of pictures, has written about the subject matter, as well as commenting upon the the power of the representation of emotion to be perceived in it:

> Here we see Haman dining with Ahasuerus and Esther,
> But it is in vain, his breast is full of grief and pain.
> He bites into Esther's food, but deeper into her heart.
> The King is consumed by anger and fury.
> The wrath of a Prince is terrifying as it rages.
> He who threatened all men was foiled by a woman.
> Thus one tumbles from the highest point down to the
> depths of adversity.
> Unhurried revenge uses the the heaviest rods.

The same is the case in the small piece representing *The Woman taken in Adultery*[1] belonging to Mr Willem Six LLM, formerly Alderman of the City of Amsterdam. Also the little painting in grisaille, *The Preaching of John the Baptist*,[2] which is astonishing for the natural depiction of the facial expressions of the

[1] London, National Gallery [2] Berlin, Gemäldegalerie

83

*The preaching of
John the Baptist,
c. 1634*

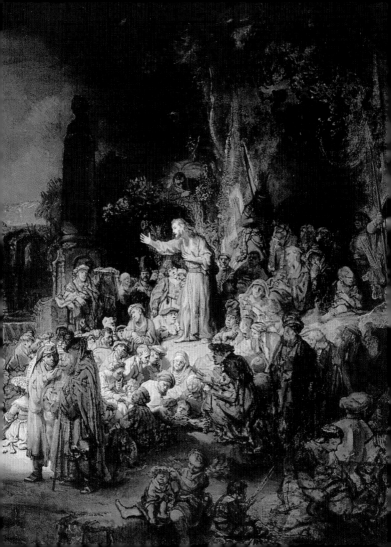

listeners and the various costumes; this is to be seen at the house of the Postmaster, Mr Johan Six in Amsterdam. As for these examples, I have to conclude that he certainly took special care with them; but he took no such pains with the rest. I am the more assured of this because various of his pupils have explained to me that he sometimes sketched a face in ten different ways before transferring it to panel. What is more, he could spend one or two days arranging a turban to his satisfaction. However, when it came to nudes he did not make so many preparations but usually daubed it in carelessly. One seldom sees a hand painted well by him and, especially in his portraits, he hides them in the shadow – unless it is the wrinkled hand of a old woman. And as to his female nudes, the noblest subject for the artist's brush, the representation of which earned the fullest attention of the most celebrated old masters, well, as the proverb says, 'too sad a song either to be sung or to be played'. His nudes are all sickening displays and one is astonished that a man of so much talent and imagination could have been so perverse in his selection of what to paint.

It would not be too much for the reader, especially

Opposite: Susanna at the Bath, 1636

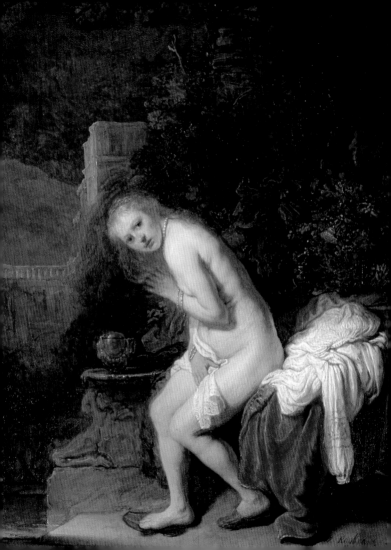

those inclined to know about the business of art according to rational and sure foundations (be it either to deploy that knowledge, or to know how to converse about it), were he to learn and understand the fundamental rules and concepts used by the great masters for the discussion of this art, which those masters have established as their principles. Nor would they mind should I compare the manner of working of two great luminaries in the art of painting and then candidly state my own opinion, along with that of Karel van Mander. He tells us that Caravaggio said that 'all painting, whatever and by whomsoever, was nothing but child's play or a trifle, unless everything was painted from life; and that there is nothing as good as, or better than, following nature; and that he did not paint one stroke unless it was to copy the object in front of him'. Rembrandt also believed this, maintaining as his basic rule 'only copy nature'. He was suspicious of anything done in any other way. What was Van Mander's conclusion? 'That it is no bad way to achieve a satisfactory result: for to paint after a drawing, however closely it follows life, is not as sure as having life itself in front of you, and copying nature with all its various colours. But of course, one must first learn to understand and know how to select the most beautiful from the beautiful.'

And it is that point, the knowledge of how to 'select the most beautiful from the beautiful', which we shall now try to establish more firmly.

We willingly concede that it is necessary and beneficial to paint from life. But it cannot be asserted as a general principle that exclusively copying from life should be the only means to achieve competence in art. If that were so then it would necessarily follow that those who chose to paint most from life would be the best masters in the art, which is not generally the case; on the contrary, many are persuaded that this is untrue. I have come across pictures in which everything is painted most laboriously after life, and with the most exacting attention to detail, but in which there is nevertheless neither correct posture, nor recession of space, nor composition, nor good draughtsmanship. And on the other hand there are others – not so precise in copying from life, but much more infused with the painter's spirit – which were sound in all the elements of art, and would pass for good and virtuous paintings.

Furthermore, there are an infinite number of things and objects, each of which has been represented in paintings, but which cannot have been made by copying from life. For example flying, tumbling, leaping or running figures whose posture and activity

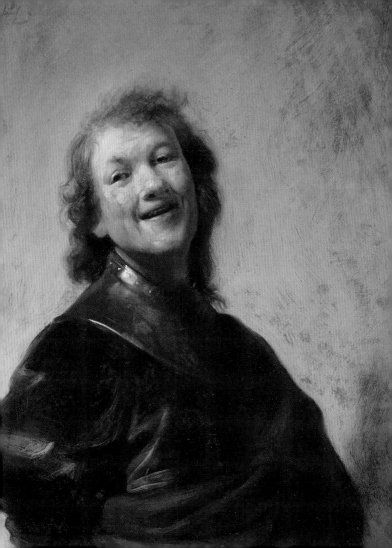

changes from moment to moment, as a result of which the painter could not work in this manner. And it is true that in every period there have been masters who, to their great renown, have understood how to paint such subjects wonderfully well following art, without copying after life. Indeed, how could those who paint such huge pieces twenty or thirty feet above the ground on scaffolds make use of copying from life? As a consequence they are obliged to paint the ideas established in their minds following cartoons of their subject matter. So, there we are again!

Say, for example, that one had to represent joy, happiness, sorrow, terror, anger, astonishment, disdain, and so forth – that is, the numerous movements of the soul, by means of copying fixed and unambiguous expressions of the face. How should one go about it? You might immediately reply that one could ask a live model to laugh and cry, and so forth, and then copy from the life. Maybe so, but it would be a picture of weeping to make you laugh, and then you would look around anxiously to see whether someone were trying to make a fool of you – for without the prompting of the soul the body cannot perform the required effect. Such facial expressions are not

Opposite:Self-portrait, laughing, c. 1628

natural when the appearance of the face is forced rather than animated by the the spirit. Consequently it is impossible to achieve art by copying from life in that way; the work must inevitably be faulty, inasmuch as the required object of the work of art is missed.

Many of the manifestations of emotion are ephemeral. Facial expressions rapidly change their appearance on the least prompting so that there is scarcely time to sketch them, let alone paint them. Consequently no other means can be imagined by which a artist could help themselves using this method other than fixing the idea in their mind by means of catching hold of a momentary particular. On the other hand, one might avail oneself of the genius of such men who, by means of established rules and the elements of art have, for the instruction of eager students, communicated to the world each particular expression of emotion in print: such as that invaluable book *Discours Académique*, dedicated to Monsieur Colbert by the masters of the Royal Academy in Paris, following which example we also have also provided samples of that kind, among other borrowed materials, and placed them in the second volume of *Philaléthes' Letters*.*

* Published anonymously by Houbraken in 1712

It is easy to say that since Rembrandt understood well how to depict particular facial expressions, and that as he was commended for it, did he not therefore do it according to established principles? My response is yes, but not according to principles that I could offer as a general instruction. By means of a wonderful ability to fix an idea in his mind, he knew how to capture the momentary appearances of emotion whenever they appeared in the face before him. He knew how to capture and insert them, and that is how he did it – a rare natural talent for which our lessons are not required. Our instruction is for those not possessed of that good fortune, and leads to skill by tried and tested means.

So as to clarify this issue of how one should properly make use of copying from life I state first of all that it must be preceded by a clearly conceived idea in one's mind of what one proposes to make. One cannot define one's ideas perfectly unless one knows and understands what is required in order to make such a work of art as is proposed – that is to say, the arrangement of the figures and the appropriate relations between them. One must arrange the model before one paints it from life. Unless one does this the whole work will fall apart. I shall now give an example of what can go wrong. If I make my point by insisting

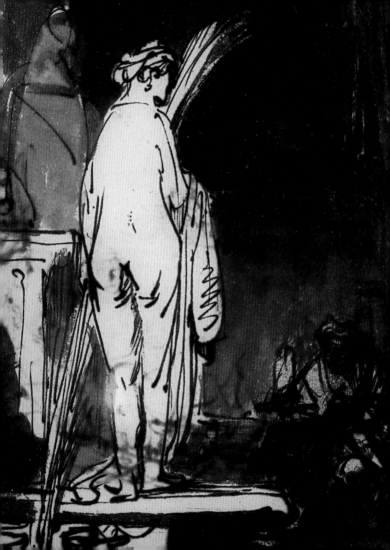

that 'in the Academy one is required to draw from life' everyone will applaud it, and readily add that 'one learns to understand life from life'. It seems indisputable, Reader, but do not judge prematurely. Most of the young folk here in Holland who copy from the naked figure draw without it doing them any good since they lack that special prerequisite of judgement and skill which would enable them to enjoy the fruits of drawing from life. This is because (I), they do not spend enough time copying fine prints and drawings from Italy and elsewhere. Also (II), they do not take enough trouble drawing from plaster casts modelled from the finest antiques, nor copying models of the most respected masters – or not enough so that they learn thereby to to discriminate between the beautiful and the rest. And (III), they do not have a fundamental grasp of human anatomy, they do not know all the muscles in the human body; they do not know how the shape of the arm or the leg is altered by the contraction or expansion of the various muscles – that what is compressed should be swollen, and that stretching produces an oblong or angular shape. The proverb 'don't go onto the ice without your skates' applies here. Without these preparations one

Opposite: The artist drawing from the model (?Pygmalion), c. 1639

cannot take a single step in art, not even if one has reached the point where one draws from the naked model. Do you wish to know why that is? Human bodies differ from each other in that muscles can appear much more plainly in one figure than in another. What shall someone untrained in anatomy make of it, therefore, when the muscles appear indefinite and indistinct? Such a person will proceed by not understanding what they see, representing on paper what they do not understand, or why it should be, and end up producing an image which is as uncertain as if they had dreamed it. On the other hand, one who understands and knows how to set the muscles according to their motions and shapes, will know how to pay attention to the least defined feature. Charles le Brun, inspector of the Academy of The King of France, has established just such a training in art, and many fine spirits and renowned painters have been produced as a result.

Vondel* expressed it very well in the *Aanleidinge ter Nederduitsche Dichtkunste*:

He who is driven on to Parnassus by his spirit, there to settle in the lap of the Muses, and is blessed by Apollo,

* Joost van den Vondel (1587-1679), the Netherlands' most celebrated poet and dramatist

serves his talent and hard work best by allowing art and study to rein it in. Otherwise such a genius, however gifted, will run wild like an unbroken horse. Meanwhile another, tamed by art and learning, succeeds like the stallion controlled and trained with the crop and spur of a good groom and horseman, and everywhere gains praise from connoisseurs.

Rembrandt, to conclude this peroration, would confine himself to no one else's rules and even less follow the example of the most celebrated artists who have earned for themselves eternal fame by selecting the beautiful. He satisfied himself copying life just as it appeared before him, without making a single choice from it. The excellent poet Andries Pels* remarked most wittily in this regard, in his *Use and Misuse of the Theatre*, p. 36, that

If, as he sometimes did, he painted a naked woman,
He took no Grecian Venus as his model but rather
A washerwoman, or a peat-treader from a barn.
He called this idiocy 'copying nature'
And everything else vain ornament. Flabby breasts,
Contorted hands, even the creases left by straps

* Andries Pels (1631-1681), classicist poet and translator of Horace. This book principally attacked Jan Vos, see above

On the body, or garters on the the leg,
They must all be copied else nature was not satisfied,
His nature, that is, which tolerated neither rules
Nor principles of proportion in the human figure.

I commend Pels' frankness, and I ask that the reader should also understand my own forthright opinion. It is not driven by hatred of this man's work, but is offered so as to contrast the different concepts and various manners of art, in order to encourage those who are eager to learn to the imitation of that which is most worthy of praise. I must also agree with the aforementioned poet when he says:

What a pity it is for Art that such an
Excellent hand, did not employ its native
Talent better! Who excelled him in painting?
Alas! The greater the spirit, the more it runs wild
When, not bound to principles and rules,
It seeks to understand everything in its own way.

Despite all this his art was so valued and sought after during his lifetime that one had, as they say, both 'to beg for it as well as pay for it'. Many years in

Opposite: Man in armour (?Alexander the Great), c. 1655

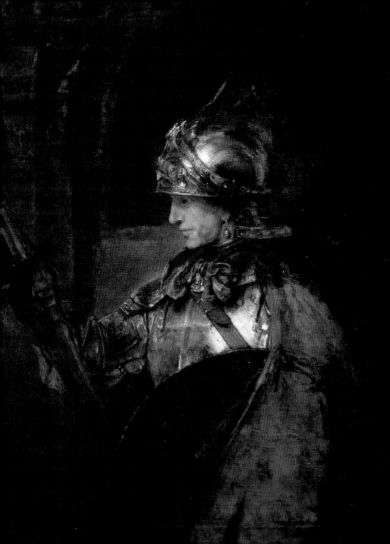

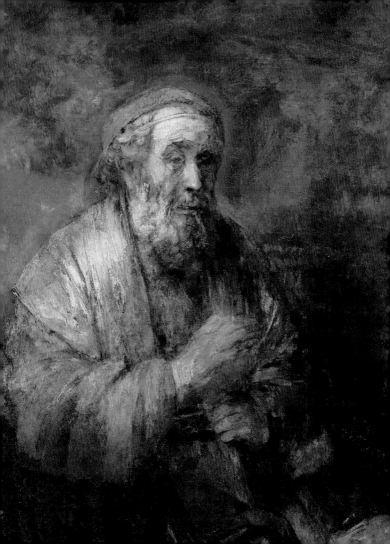

succession his painting kept him so busy that people had to wait a long time for their works, notwithstanding that he worked so rapidly. This was especially the case during his last years when, seen from nearby, his paintings looked as if they had been laid on with a trowel. This is the reason why, when people visited his workshop and wished to view his works from close to, he pulled them back saying 'the smell of the paint will upset you'. It is said that he once painted a portrait with paint so thick that one could pick it up by its nose. You see also jewels and pearls painted by him in necklaces and turbans so impasted that they stand in relief – it is on account of this manner of working that his pieces appear so powerful, even when seen from a distance.

Of the many celebrated portraits that he made there is one, a self portrait,[1] belonging to Mr Jan van Beuningen which is depicted so artistically and effectively that it outdoes the most powerful brushwork of Van Dyck and Rubens. Indeed, the head appears to project and to speak to the spectators. No less praise is accorded to the power of the self portrait[2] which hangs in the gallery of the Grand Duke of Florence

[1] Lost [2] Florence, Uffizi

Opposite: Portrait of Homer, 1663

alongside the self portraits of Philips de Koninck, Frans van Mieris, Gerrit Dou, Bartholomeus van der Helst, Jacob Ferdinand Voet of Antwerp, Michiel van Musscher, Godfried Schalcken, Gerard de Lairesse, Adriaen van der Werff, Carel de Moor and Eglon van der Neer.

We have said enough as regards his brushwork. We wish now, even though this account of his life is already getting quite long, to say something about his natural and inimitable etchings. They would be sufficient in themselves to maintain his fame. There are about a hundred of these known to print lovers, and no fewer sketches in pen on paper. Emotions relating to situations are so artistically and skilfully depicted by means of facial expressions that it is astonishing. Anger, hatred, sorrow, joy and so forth – every thing is depicted so naturally that one can read each figure from the strokes of the pen. One which stands out from among many excellent works is the *Last Supper*[1] I saw at the house of the art-loving Van der Schelling, now in the possession of Mr. Willem Six, whom we have often mentioned. It is valued at more than twenty ducats, even though it is no more than a sketch in

[1] After Leonardo da Vinci; Berlin, Staatliche Museen, Kupferstichkabinett

pen on paper. From this one must conclude that he was excellent at representing the various emotions, impressing a fixed idea of them in his mind.

He has produced many witty Histories, Figures, little Portraits and numerous male and female heads with his needle, many of which are etched on copper, which have been circulated thanks to the press and to the delight of lovers of art.

He had his own particular manner of preparing and handling his etched plates, something he never shared with his pupils. It is not possible to know how it was done, and thus the invention has gone to the grave with its inventor (as did the technique of colouring glass used by Dirk and Wouter Crabeth of Gouda).

There are three different states of the small *Portrait of Lutma*, which shall serve as an example for all the others. The first is roughly sketched, the next is a little more completed and includes a window, and the last is finished carefully and powerfully.[1] One can also see that the *Portrait of Sylvius* is likewise first roughly sketched before the introduction of gentle scintillating shadows and more forceful details, and it is as finely

[1] *Jan Lutma*, 1656, reproduced p. 79 [2] *Medea: or the Marriage of Jason and Creusa*, 1648

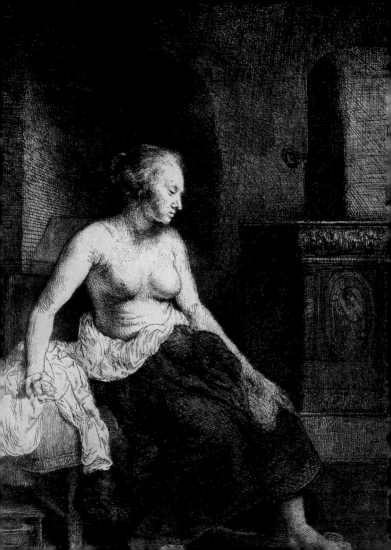

and softly handled as a mezzotint. Doing this brought him great fame and no small profit, as did the trick of making minor alterations, or adding small and unimportant details to his prints, by means of which they could be resold as new designs. The rage for his works was then so great that anyone who did not own both the little *Juno*[2] with and without her crown, or the little *Joseph*[1] with and without the dark throne, and others besides, was not considered a true lover of art. Yes, everyone wanted *The Woman by the Stove*,[2] one of the least of his works, with and without the white bonnet, with and without the stove even though, as if it were not important enough for him to be bothered with it, he allowed it to be sold through his son Titus.

What is more he had so may pupils, each of whom paid 100 guilders annually, that Sandrart, who used to be close to him, calculated that 'Rembrandt earned 2,500 guilders a year through his pupils'. Furthermore, he was so fond of money (I shall not say greedy) that it was noticed by his pupils and as a trick they painted pennies, two-penny coins and shillings on the floor, or wherever he was likely to see them. He fre-

[1] *Joseph telling his Dreams*, 1638 [2] *Woman sitting half-dressed by a Stove*, 1658

Opposite: Woman sitting half-dressed by a Stove, etching, 1658

quently and secretly reached out for them in vain, embarrassed lest anyone should see him:

'Money cannot satisfy desire.'

Add to this what he earned with his brush, for he made people pay handsomely for his paintings. In this way he must necessarily have made a great deal of money. All the more since he was not the kind of man who wasted money in the tavern or among company, even less at home where lived modestly. When he was working he frequently dined on no more than bread and cheese, or pickled herring. Nevertheless, nothing is rumoured about a large estate at his death, which occurred in the year 1674.*

His wife was a farm-girl from Raarep, or Ransdorp, in Waterland; a small woman with a pretty face and a chubby figure. She can be seen together with him in one of his prints,[1] the one we used as a source for his portrait, which can be seen on plate M, beneath that of Anna Maria Schuurmans.

He spent the autumn of his life in the company of

* In fact 1669 [1] *'Rembrandt and his wife Saskia: busts'* (1636), but Houbraken is talking about Hendrickje, to whom Rembrandt was in fact never legally married.

Opposite: Bathsheba with King David's letter, 1654

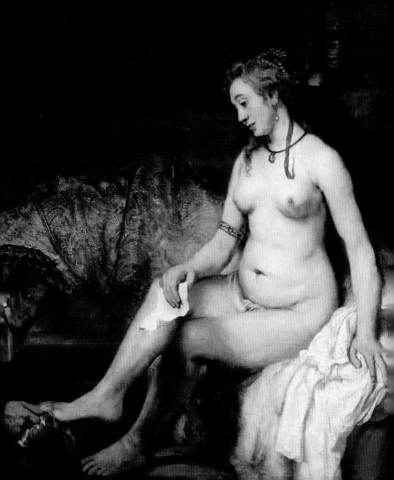

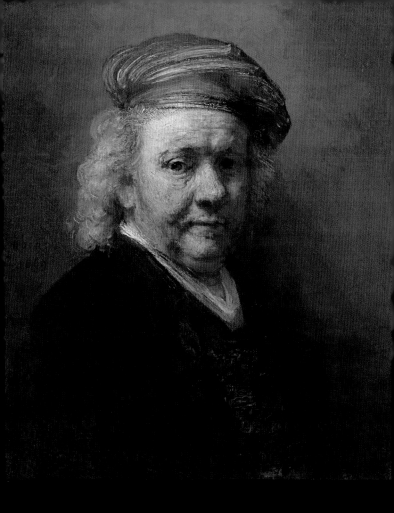

ordinary folk and practitioners of art. Perhaps he was acquainted with Gratian's* rules for the good life where he says 'It is good to keep company with distinguished people in order to achieve distinction. But once that is achieved one should mix with ordinary people.' To which Rembrandt adds the following explanation: 'If I want to relieve my spirit, then I should not seek honour, but freedom.'

As regards his method of painting (although contemptible in many ways) I have to conclude that he did as he did on purpose. Had he painted in a manner which followed that of anyone else, or laid his brush at the foot of any celebrated Italian, or at the feet of any other highfliers, the world would recognised his borrowings by comparing the one with the other. By doing the very opposite he anticipated any unfavourable comparison, like Tiberius, as related by Tacitus, 'who always avoided anything that would give the people an opportunity to compare him with Augustus, knowing that his memory was fondly cherished by all.'

* Baltasar Gracián y Morales (1610-1658), a Spanish Jesuit priest, teacher and philosophical writer frequently quoted by Houbraken

Opposite: Self-portrait, 1669

Illustrations

All works oil on canvas, unless otherwise specified

p. 1: Self-portrait, c. 1628, pen, ink and wash on paper, 127 x 94 mm,
Amsterdam, Rijksmuseum

p. 2: Young man (?Titus) in a Franciscan habit, 1660, 79 x 67 cm,
Amsterdam, Rijksmuseum

p. 4: Young woman (?Hendrickje Stoffels) sleeping, c. 1655, pen, ink and wash on
paper, 246 x 203 mm, London, British Museum

p. 6: Self-portrait, 1658, 133 x 103 cm, New York, Frick Collection

p. 11: Sarah awaiting Tobit (?Hendrickje Stoffels), c. 1649, 81 x 67 cm,
Edinburgh, National Gallery of Scotland

pp. 14-15: Portrait of a man with a tall hat and gloves; portrait of a woman
with an ostrich-feather fan, 1658-60, each 99 x 83 cm,
Washington, National Gallery of Art

p. 17: Self-portrait with beret and two gold chains, c. 1642-3, oil on panel,
72 x 45 cm, Madrid, Museo Thyssen-Bornemisza

p. 18: Self-portrait, 1659, 84 x 66 cm, Washington, National Gallery of Art

p. 20: Anna accused by Tobit of stealing the kid, 1626, oil on panel, 39 x 30 cm,
Amsterdam, Rijksmuseum

pp. 22-3: The Anatomy Lesson of Dr. Nicolaes Tulp, 1632, 169 x 216 cm,
The Hague, Mauritshuis

p. 25: Samson threatening his father-in-law, 1635, 159 x 131 cm,
Berlin, Gemäldegalerie

p. 26: Aristotle contemplating the bust of Homer, 1653, 143 x 136 cm,
New York, Metropolitan Museum

pp. 28-9: The Syndics of the Drapers' Guild, 1662, 191 x 279 cm,
Amsterdam, Rijksmuseum

p. 31: Hendrickje Stoffels, c. 1654, 86 x 65 cm, Berlin, Gemäldegalerie

p. 32: Titus reading, 1656, 70 x 64 cm, Vienna, Kunsthistorisches Museum

p. 34: The return of the Prodigal Son, 1669, 262 x 205 cm,
Saint Petersburg, Hermitage

p. 36: The Mill, 1645-8, 87 x 105 cm, Washington, National Gallery of Art

p. 38: Self-portrait, c. 1628, oil on panel, 23 x 19 cm, Amsterdam, Rijksmuseum

pp. 40-1: Portrait of the Mennonite Preacher Cornelis Claesz. Anslo and his wife
Alltje Gerritsdr. Shouten, 1641, 176 x 210 cm, Berlin, Gemäldegalerie

p. 43: A man embracing a woman, ('The Jewish Bride'), c. 1663, 121 x 166 cm,
Amsterdam, Rijksmuseum

p. 45: Girl at a window, 1645, 81 x 66 cm, London, Dulwich Picture Gallery

First published 2007.
This revised and enlarged edition published 2014 by
Pallas Athene,
Studio 11B, Archway Studios, 25-27 Bickerton Road, London N19 5JT
www.pallasathene.co.uk
© Pallas Athene 2007, 2014
Special thanks to Xavier F. Salomon

ISBN 978-1-84368-104-5

Printed in China

NOTE ON THE TEXTS:

Joachim von Sandrart's *L'Academia Todesca della architectura, scultura
et pittura: oder Teutsche Academie der edlen Bau-, Bild- und Mahlerey-Künste*
('The German Academy of the Noble Arts of Architecture, Sculpture
and Painting), was published in German in Nuremberg in 1675,
and in a Latin edition in 1683.
This translation is a corrected version of one first published in
Tancred Borenius, *Rembrandt*, Phaidon Press, 1942.
The text was revised by Ulrike Kern and Charles Ford.

Filippo Baldinucci's *Cominciamento, e progresso dell'Arte dell'Intagliare
in Rame, colle Vite di molti de' più eccellenti Maestri della stessa Professione*
('The origins and development of the Art of Engraving on Copper,
with the lives of many of the most excellent Masters of that Profession'),
was published in Florence in 1686.
This translation is a corrected version of one first published in
Tancred Borenius, *Rembrandt*, Phaidon Press, 1942.
The text was revised by Francesca Migliorini and Charles Ford.

Arnold Houbraken's *De Groote Schouburgh der Nederlantsche Konstschilders en
Schilderessen* ('The Great Theatre of Netherlandish Painters and Painteresses')
was published in three volumes in Amsterdam between 1718 and 1721.
This translation is by Charles Ford.